THE WIND THE AIR THE MOTION THE MOMENT THE FRE

THE BIKE THE RELEASE THE TATTOO THE LEATHER THE

THE COLOR THE MOMENT THE THOUGHT THE TONE T

THE SEEING THE FEELING THE DREAMING THE DOING T

THE ADRENALINE THE PULSE THE BEAT THE MUSCLE TH

THE BROTHER THE SISTER THE GIRL THE WAVE THE WI

THE DAY THE GIVE THE TAKE THE LIGHT THE NIGHT TH

THE BIKE THE FREEDOM THE WIND THE AIR THE MO

THE SPACE THE RHYTHM THE ZEN THE BIKE THE RELEASE

THE GAS THE TREE THE CLOUD THE COLOR THE MOMEN

THE GOING THE MEETING THE SEEING THE FEELI

THE THRILL THE DANGER THE EMOTION THE ADRENAL

THE POP THE SPARK THE FRIEND THE LOVE THE BROTHE

THE SUNSET THE NEW THE PLAY THE FUN THE DAY THE G

THE MOON THE SUN THE RIDE THE PRIDE THE BIKE TH

THE FREEDOM THE RIDE THE FEELING THE SPACE T

HE RIDE THE FEELING THE SPACE THE RHYTHM THE ZEN

THE SMELL THE ESSENCE THE GAS THE TREE THE CLOUD

SION THE EXHILARATION THE GOING THE MEETING

IG THE GIVING THE THRILL THE DANGER THE EMOTION

T THE PISTON THE POP THE SPARK THE FRIEND THE LOVE

LIFE THE WAY THE SUNSET THE NEW THE PLAY THE FUN

T THE FLIGHT THE MOON THE SUN THE RIDE THE PRIDE

HE MOMENT THE FREEDOM THE RIDE THE FEELING

TOO THE LEATHER THE SPIRIT THE SMELL THE ESSENCE

HOUGHT THE TONE THE PASSION THE EXHILARATION

E DREAMING THE DOING THE BEING THE GIVING

E PULSE THE BEAT THE MUSCLE THE HEART THE PISTON

ISTER THE GIRL THE WAVE THE WINK THE LIFE THE WAY

E TAKE THE LIGHT THE NIGHT THE RIGHT THE FLIGHT

DOM THE WIND THE AIR THE MOTION THE MOMENT

YTHM THE ZEN THE BIKE THE RELEASE THE TATTOO

THE BIKER CODE

A SAFE BLESSING TO EVERY
GIVING—LIVING—LOVING BIKER

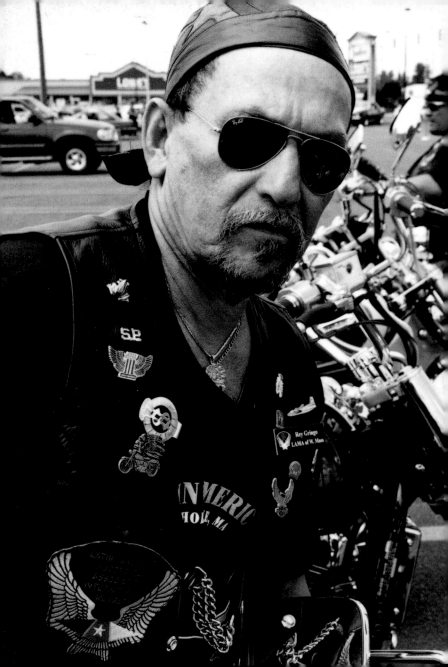

THE BIKER CODE
WISDOM FOR THE RIDE

PHOTOGRAPHS AND INTERVIEWS BY
STUART MILLER
GEOFFREY MOSS

SIMON & SCHUSTER PAPERBACKS
NEW YORK ~ LONDON ~ TORONTO ~ SYDNEY

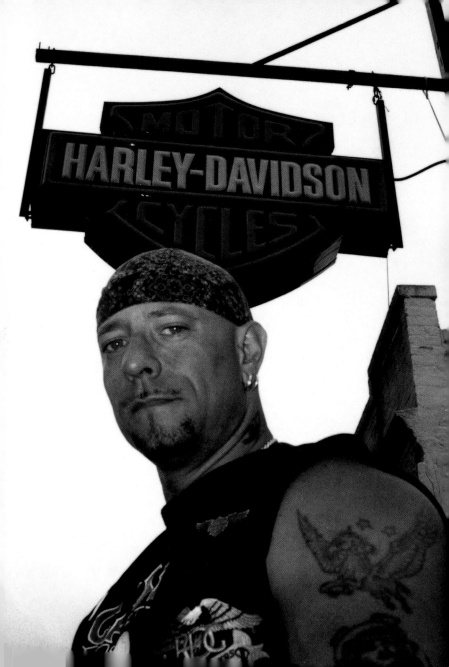

EVERY BIKER IS AN AMERICAN BIKER.

THE SUNDAY AFTER THE TRADE TOWERS WENT DOWN,
20,000 OF US DID A RUN TO THE NEW JERSEY VIETNAM
MEMORIAL TO RAISE MONEY TO BENEFIT THE VICTIMS.

EVERYBODY HAS A BAD LOOK OUT FOR BIKERS.
AMERICANS WOULD HAVE CHANGED THEIR MINDS
IF THEY HAD SEEN US; AT LEAST 18,000 WERE
HARLEY–DAVIDSONS. SOME GUYS EVEN PAINTED
THEIR FACES RED WHITE AND BLUE; AND FLAGS,
LOTS OF FLAGS. AND EVERYBODY CHEERING US ON.

WE'RE AMERICA'S SYMBOL OF FREEDOM AND THEY
DIDN'T EVEN SHOW IT ON T.V. THAT NIGHT.

James "Spike" Basso
Carpenter + Riding 20 years
2000 Harley-Davidson Super Glide

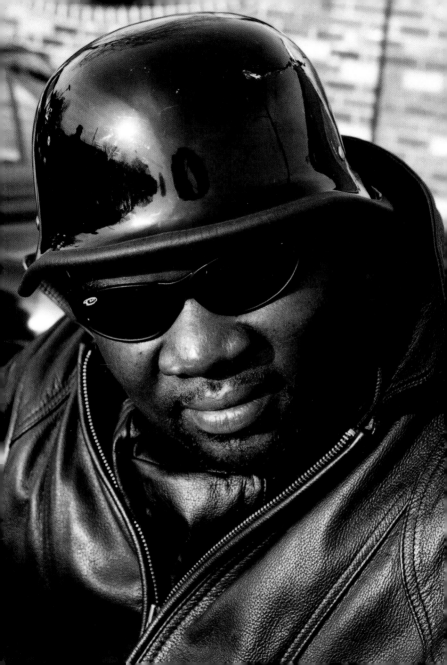

ALL YOU NEED IS A MUSTARD SEED OF RIDING IN YOU.
THE REST WILL TAKE CARE OF ITSELF.

THE GOOD WE DO
NO ONE REMEMBERS,
THE BAD WE DO NO ONE FORGETS.

Stephen "Rhino" Williams
Professional Vocalist and Song Stylist
Riding 18 years + Harley-Davidson 1340 Softail

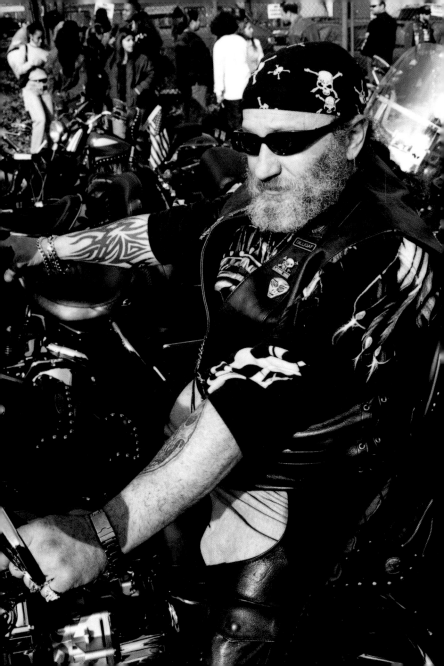

IF YOU'RE A STREET RIDER,
DON'T RIDE LIKE AN ASSHOLE.

✦

Al "Smurf" Jacoby
Auto Mechanic ✦ Riding 30 years
Valkyrie Interstate

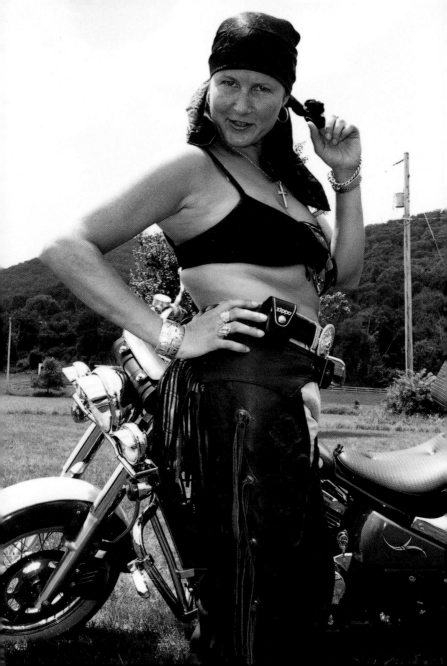

I RIDE BECAUSE DADDY ALWAYS SAID NO.
I RIDE BECAUSE IT FEELS GOOD.
I RIDE ALONE.

WHAT FREEDOM! WHAT POWER!

NOW I HAVE A REASON FOR WEARING LOTS OF
LEATHER WITHOUT BEING ACCUSED OF SOLICITING.

✦

Allison Thorner
Fashion Retailing + Riding 3 years
1996 Kawasaki Vulcan 800 Classic

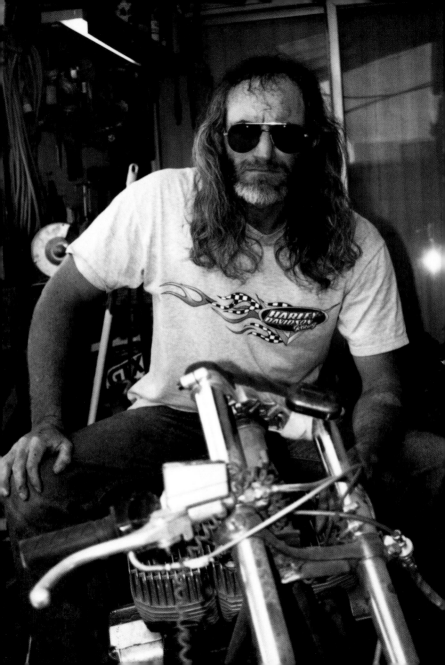

RIDE FOR THE FREEDOM AND THE POWER.
RIDE HARD—WIDE OPEN THROTTLE—HAVE FUN.

TO SURVIVE, BE AGGRESSIVE, LOOK MEAN,
AND HAVE A "BAD" BIKE.

WATCH OUT FOR THOSE "CAGERS"—
THEY'LL RUN YOU DOWN IN A MOMENT'S TIME.

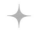

Mark "Goose" Giesen
Heavy-Equipment Operator ✦ Riding 20 years
Harley-Davidson

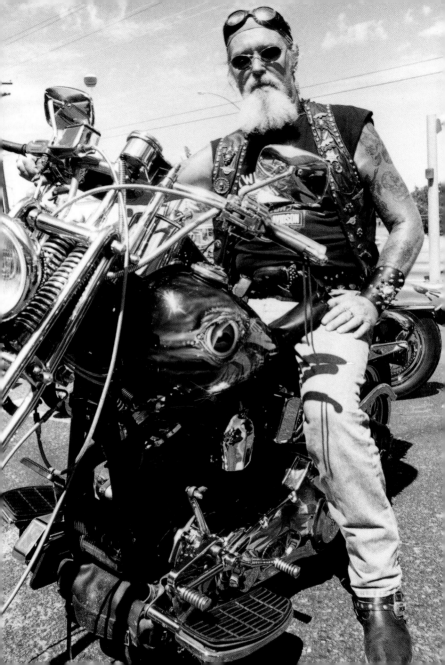

BEWARE! EVERY "CAGE" OUT THERE
IS A POTENTIAL ENEMY.

NEVER SNUB ANY RIDER NO MATTER WHAT HE RIDES.
SOMEDAY WE WILL NEED EVERY BROTHER WE CAN GET
TO FIGHT OFF THE MAN TRYING TO OUTLAW US.

I RIDE ALONE.
IT'S A FEELING OF FREEDOM, NOISE, WIND AND SPEED.

Thomas "Road Kill" Anderson
Retired • Riding 35 years
Harley-Davidson

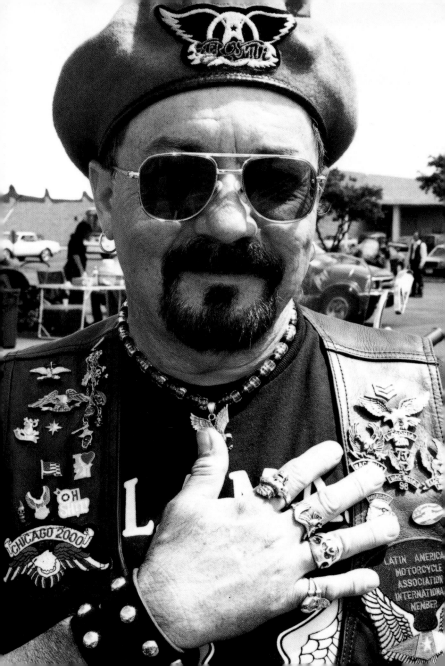

BEFORE I RIDE I ALWAYS
COMMEND MYSELF TO GOD.

I FEEL FREE LIKE AN
EAGLE FLYING ON THE HEIGHTS.

RIDING WITH "ROLLING THUNDER" TO THE VIETNAM
VETERANS MEMORIAL IN WASHINGTON, D.C.—
TO HEAR AND FEEL THE RUMBLE OF THE BIKES—
THE BEST EXPERIENCE I EVER HAD.

Carlos "Marlboro" Rivera
Retired ✦ Riding 15 years
1998 Yamaha Virago 1100 Special

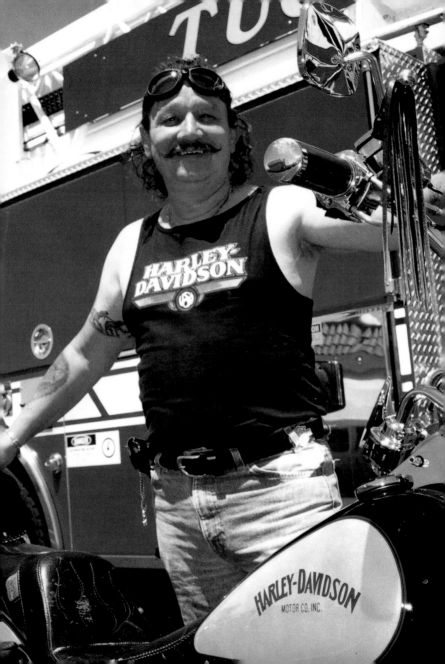

RIDE FOR THE LOVE OF LIFE
AND ALL THAT GOES WITH IT.

DON'T TRY TO EXPLAIN MATTERS OF THE HEART.

GET LOST IN THE MOMENT.

EXPECT THE UNEXPECTED.
BE AWARE—AND ALWAYS PREPARED TO RIDE.
KNOW WHEN TO COME HOME.

John "Reb" Everett

Product Assurance Engineer + Riding 35 years
Harley-Davidson FLSTC Heritage Classic Softail

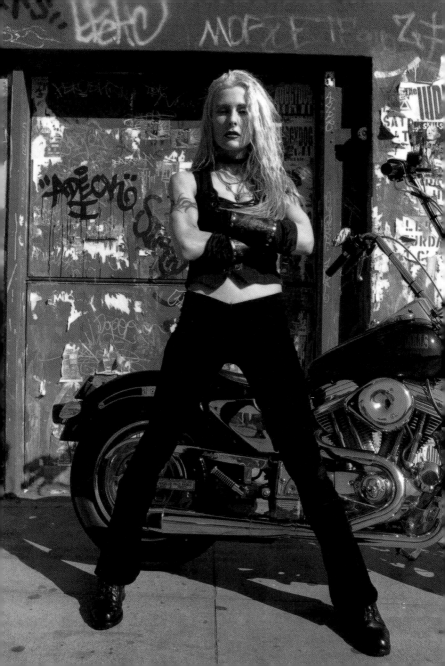

EMOTIONAL REACTIONS

ARE DANGEROUS—

KEEP YOUR EYES ON THE ROAD.

✦

Goth Girl
Biker Chick + Riding 15 years
Heavy Custom 1998 Harley-Davidson

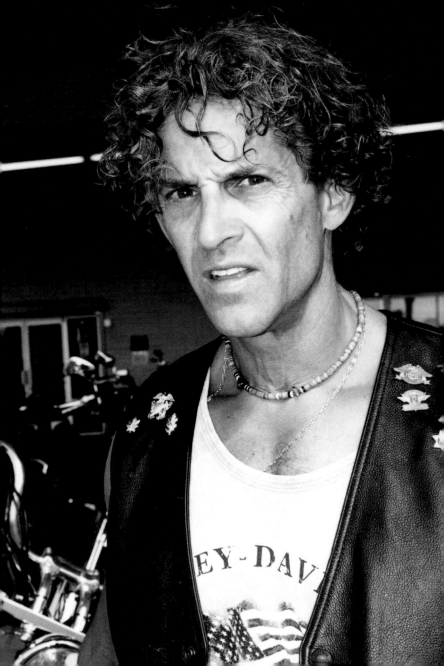

RIDE TO CREATE A MOOD,
TO EXPERIENCE THE BEAUTY
AND ROMANCE OF THE ROAD.

STRESSED? UNFOCUSED?
SCRUB THE RIDE FOR ANOTHER DAY.

RIDING IS AN ANTIDOTE TO MY WAY OF LIFE.
LONG AGO I DISCOVERED THAT GETTING OUT ON
THE OPEN ROAD IS MY CURE FOR PSYCHIATRY.

TO THE BEAUTY AND ROMANCE OF THE ROAD—
ADD FREEDOM.

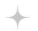

Daniel J. Fredman M.D.
Psychiatrist · Riding 34 years
Harley-Davidson FLSTC Heritage Classic Softail

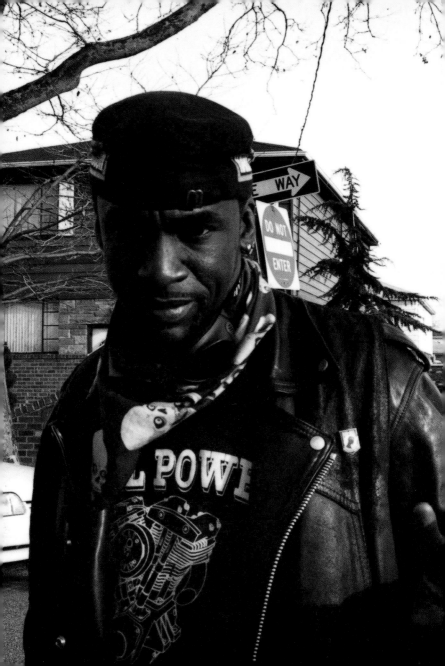

KEEP IT REAL. DON'T BE FAKE
AND HANDLE YOUR BUSINESS.

BE TRUE TO THE GAME.

Mike "Brooklyn" Brown
Mechanic • Riding 18 years
1979 Harley-Davidson Low Rider Shovel Head

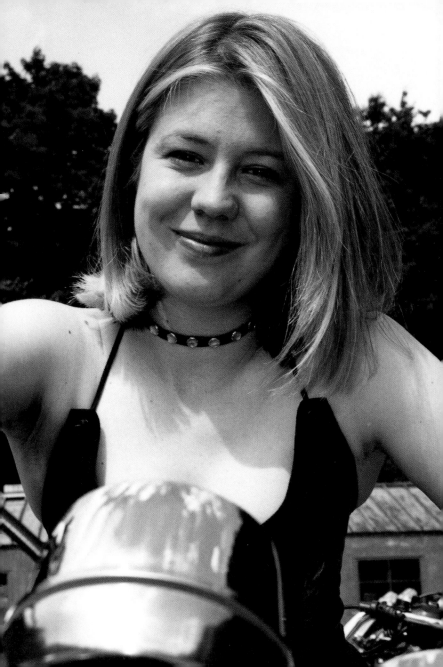

TEACH YOURSELF?
CHEAT THE ODDS. FLIRT WITH DEATH.

REALIZE YOUR LIMITATIONS.
DON'T THINK YOU KNOW THE UNIVERSE.

I TEACH MORE THAN SKILL.
THE RIDE IS MORE THAN TEXTBOOK. MORE THAN
"FINE"—FUEL, IGNITION, NEUTRAL, ENGINE.

I RACE WEARING FULL LEATHER FOR THE TRACK.
IT'S A MENTAL CHALLENGE AT 120 MPH.
IT'S WHAT EVERYONE THINKS YOU SHOULDN'T DO.
THAT'S WHY I LOVE IT.

MY DIRTY LITTLE SECRET ?
EARPLUGS—BLOCKING OUT WHISTLING WIND,
SAVING MY HEARING, WHILE I'M GOING
FASTER THAN YOU.

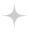

Diane Howells
Owner, Motorcycle Safety School · Riding 6 years
1998 Honda Super Hawk VTR 1000

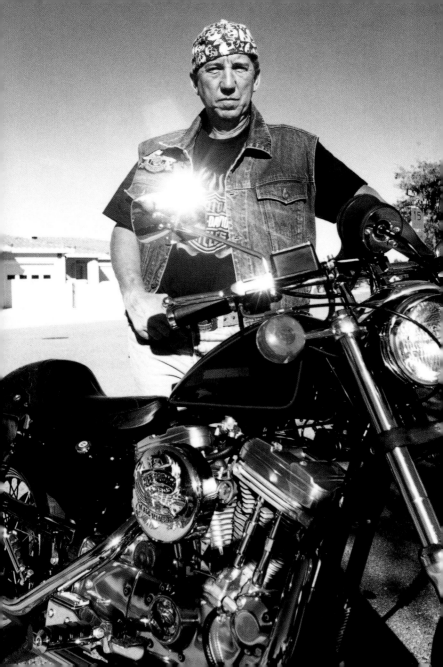

I RIDE FOR THE FEELING AND
THE POWER OF THE MOTOR.
I RIDE BECAUSE I'M FREE.

DON'T GET COMPLACENT ABOUT YOUR SKILLS.
NO ALCOHOL.

TAKE CARE OF YOUR BIKE.
CLEAN, WIPE, POLISH, INSPECT...

BE EVER VIGILANT—
YOU COULD LOSE EVERYTHING IN A MOMENT.

Mike Burnett
Alarm & Security Salesman ✦ Riding 3 years
1988 Harley Sportster XL

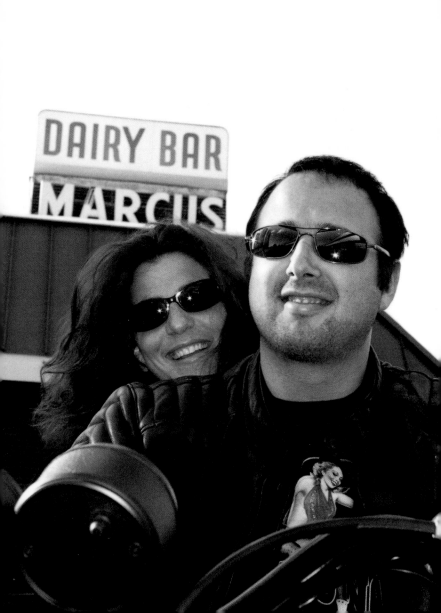

ON SUNDAYS BIKERS COME TO MARCUS DAIRY FOR
BREAKFAST. MY FIRST MEMORIES: MOTORCYCLES—OLD
KNUCKLE HEAD CHOP TO FULL BLOWN CUSTOM.
A BIKER BITCHING—CARS ON HIS TAIL, REACHING
INTO SADDLEBAGS FOR TENPENNY NAILS HE WELDED
INTO JACKS THROWN AT THE CAGES. WRONG.

ROMANTIC TO A KID: ROUGH AMERICAN BIKERS, THE
OLD WEST, RACING FOR TITLES, BIG HARLEYS STOPPING
TRAFFIC DOING FIGURE EIGHTS, BURNING OUT, SMOKING
THE PARKING LOT.

IN THE '90S, IT GOT CALMER. NOW NO POLICE SHOW UP.
QUIETER THAN NORMAL AFTER 9/11, OUR BIKES WERE A
SEA OF FLAGS. IT WAS A THOUSAND HEARTS WONDERING
IF ANY CAUGHT BY THE TRAGEDY HAD BEEN PART OF
OUR SUNDAYS.

✦

Sean Marcus
Warehouse Operations Manager
Riding 15 years + Harley-Davidson FXDX
Gina Marcus
Art Museum Fund Raiser + Riding 6 years

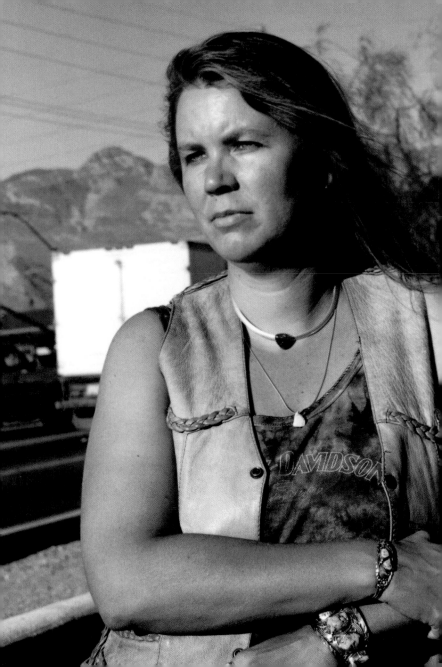

TO DISCOVER NEW PEOPLE WHILE BIKING,
TO BE BATHED IN THE CHARM OF
AN UNFAMILIAR PLACE,
TO HEAR THE SPIN–SONG OF
WHEELS ON THE ROAD,
THESE ARE THE INGREDIENTS OF A GOOD RIDE.

BUT AS FOR DANGERS:
RIDING WHILE DAYDREAMING,
RIDING WHILE ANGRY.
THESE ARE THE TWO ALTERNATIVE DWI'S.

Kay "Amazon" Howard
Self-Employed + Riding 17 years
1991 Harley-Davidson FXRS Low Rider

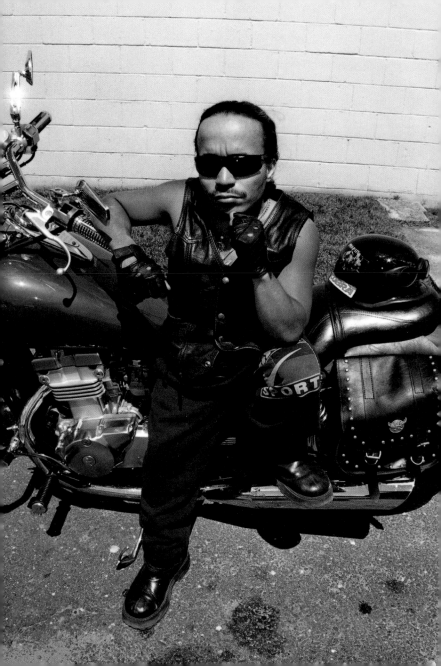

I MAKE PEOPLE SEE THAT
THE IMPOSSIBLE IS POSSIBLE.

BY BEING SMALL I HAVE MADE A DIFFERENCE.

BEING A BIKER MAKES MY WORLD A LOT SMALLER.
I DON'T FEEL AFRAID TO GO ANYWHERE
OR MEET ANYBODY.

PEOPLE WANT TO BE LIKE ME, DO AS I DO.

BY NATURE WE ARE EXPLORERS,
GOING WHERE NO ONE HAS GONE BEFORE—
LIKE THE SPANIARDS DISCOVERING THE NEW WORLD.

Alex "Mini Rebel" Cruz
Medical Clinic Receptionist · Riding 4 years
Kawasaki Vulcan EN 500C

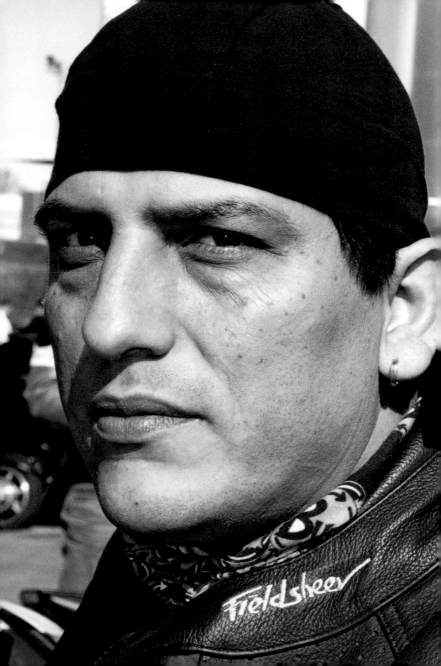

AS A CHEF I'M ARTISTIC BECAUSE
I'M CREATING SOMETHING.

AS A MOTORCYCLIST I'M TRYING TO FIND
THE PEACE OF MIND TO CREATE.

Edward Delgado
Chef + Riding 20 years
Honda 929RR

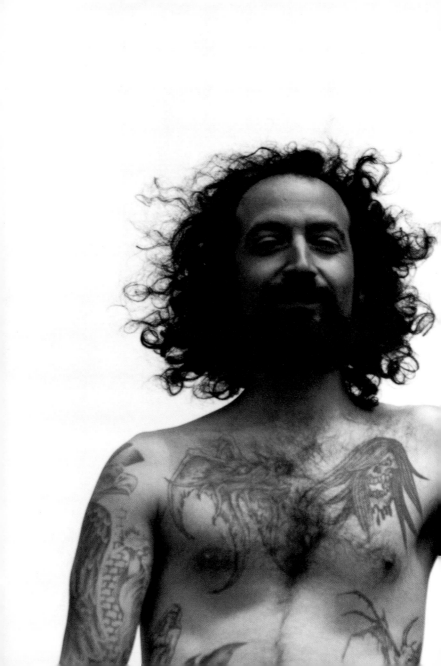

I AM A QUIET PERSON.
WHEN I'M RIDING, ALL OF THAT GOES AWAY.
I ENJOY TAKING RISKS AND HAVING
THE SKILL YOU NEED TO STAY ALIVE.

RIDE LIKE YOU'RE INVISIBLE.

MAKE A DECISION, KEEP YOUR
HEAD STRAIGHT, RELAX, GO.

EXPECT THE UNEXPECTED.
DON'T RIDE WITH AN ATTITUDE.

David "Leather Guy" Hodes
Antiques Restorer/Upholsterer
Riding 25 years + 1986 Harley Sportster

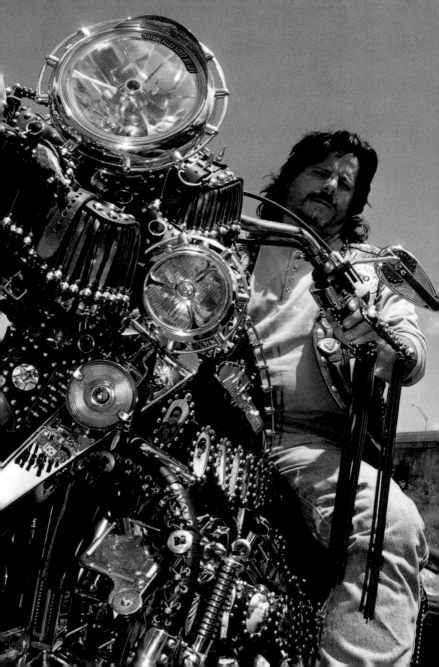

I'M AN ARTISAN,
AS WERE MY FATHER AND GRANDFATHER.
I BEGAN TO DECORATE MY BIKE WITH PHOTOS OF MY
SONS ON THE CHROME SPEEDOMETER RAIL. I ADD PEOPLE
WHO INFLUENCED MY LIFE. THOSE DECEASED ARE ON
THE LEFT, THOSE LIVING ARE ON THE RIGHT. THE ONLY
TIME ONE IS REMOVED IS TO MOVE IT FROM THE RIGHT
TO THE LEFT. ALWAYS WITH SADNESS AND RESPECT.
BEFORE EVERY RIDE I LOOK DOWN AT MY DASH TO SEE
THE PICTURES OF MY FAMILY, TO REMIND MYSELF OF
WHAT I HAVE TO COME BACK TO.

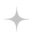

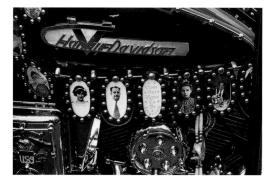

Joe "Doughnuts" Biunno

Antique Furniture Restorer

Riding 25 years + 1989 Harley-Davidson Heritage

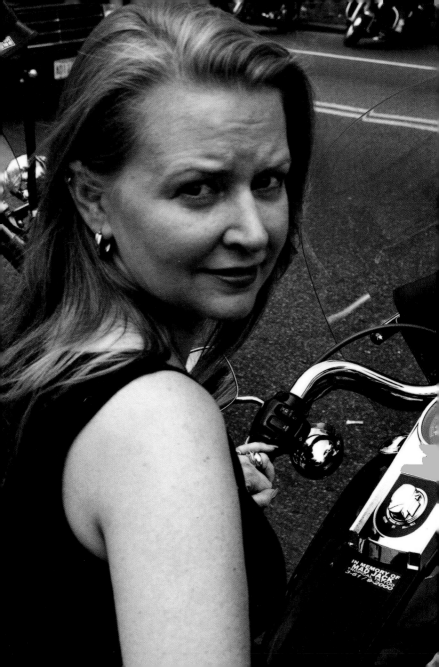

FOR SOME THERE'S THERAPY,
FOR THE REST OF US THERE'S MOTORCYCLES.

YEARS AGO, I FOUND MYSELF
DANGEROUSLY CLOSE TO A DEPRESSION.
I HAD 2 OPTIONS: SPEND THE NEXT 5 YEARS
AND THOUSANDS OF DOLLARS IN THERAPY,
OR TAKE A "NONCONVENTIONAL" APPROACH.
I BOUGHT A 1987 1100 HARLEY SPORTSTER.

THE BEST THERAPIST EVER.

Grace "Amazing Grace" Verderosa
Technical Designer + Riding 9 years
Harley-Davidson 2001 Softail

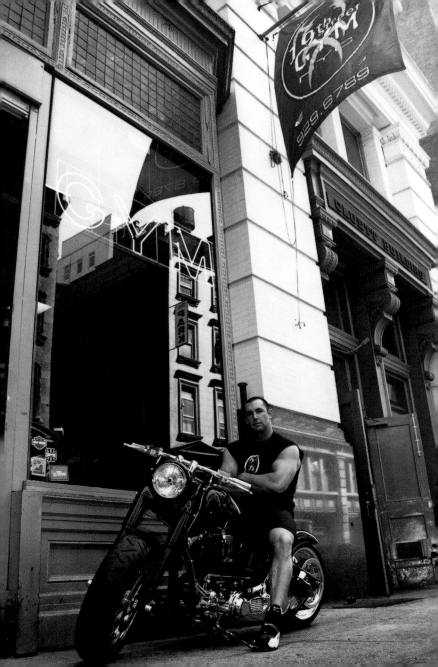

I'VE BEEN RIDING ALL MY LIFE.
I WAS BORN INTO IT. IF I HAD ONE PERSON
TO RIDE WITH, IT WOULD BE MY FATHER.
WE'RE BEST FRIENDS BECAUSE OF THE BIKES.

MY LIFE IS BASED ON POWER.
MUSCLE GIVES ME THE UPPER HAND.

I DON'T KNOW IF I'M LIVING
ON THE EDGE OF SURVIVAL,
BUT I'M DEFINITELY LIVING ON THE EDGE.
I WOULDN'T KNOW HOW TO GET
HAPPINESS WITHOUT IT.

I WOULD NEVER GET OFF A MOTORCYCLE. NEVER.

Tommy "T" Marinelli
Owner 19th Street Gym • Riding 24 years
1994 Harley-Davidson Fat Boy

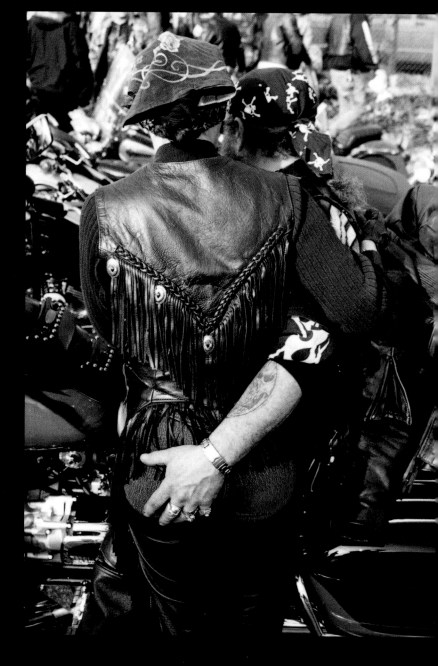

Threatened. Accelerate.

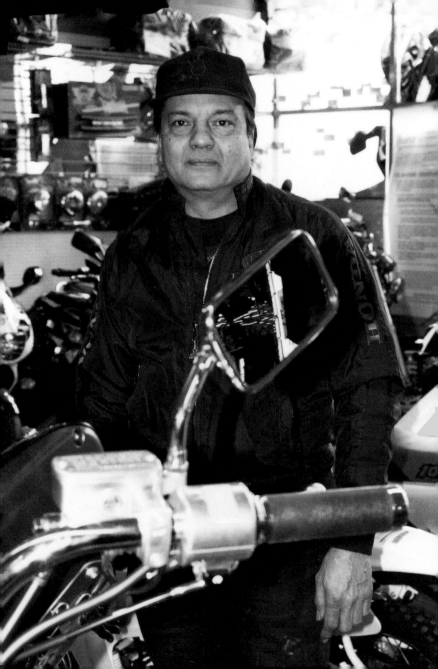

KNOW YOUR CAPABILITIES.

KNOW WHO YOU ARE RIDING WITH.

STUDY TRAFFIC AND STAY AWAY FROM BRAKE LIGHTS.

"ALWAYS RIDE AS IF..."
ALL OTHER DRIVERS ARE OUT TO GET YOU.
ALL ROADS ARE UNDER CONSTRUCTION.
YOU AND YOUR MACHINE ARE COMPLETELY INVISIBLE.

Pete Agtuca
Heavy Metal Shop Owner · Riding 39 years
Honda Goldwing

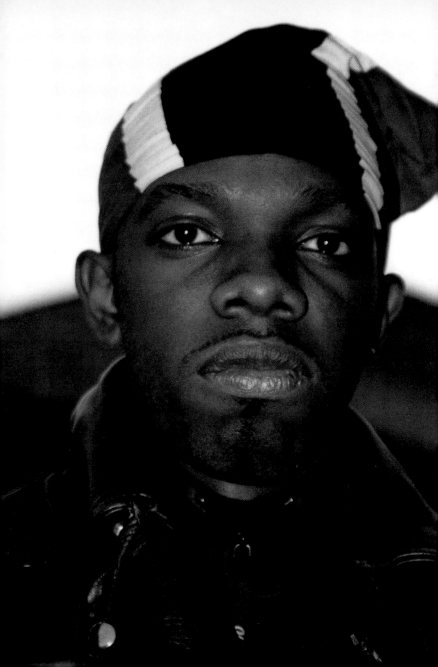

MY FATHER RODE—IT'S IN MY BLOOD.

CLEAN BIKE.
SAFETY CHECKS.
PRAYER.

RIDE OR DIE, BABY.

✦

Ariel "Prince" Darmanie
Client Associate, Banking · Riding 4 years
Kawasaki Vulcan 500C

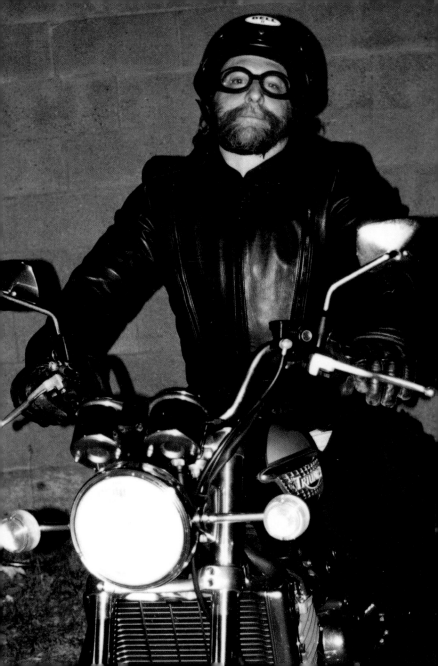

ALWAYS LEAVE AN ESCAPE ROUTE.

DON'T RIDE BEFORE NOON.

REMEMBER—
TURN ON THE GAS.
TURN ON YOUR LIGHTS.
TURN ON YOUR HEAD.

✦

Marty "Flash" Sabba
Psychotherapist · Riding 30 years
BSA & Triumph

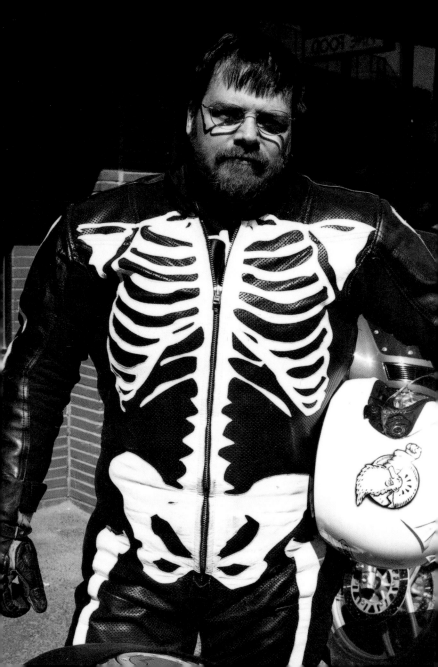

I'M A FUNERAL DIRECTOR ON CALL 24/7,
AND I HAVE TO BE MATURE AND DIGNIFIED.
THIS DOESN'T COME NATURALLY.

WHEN I SUIT UP, I DROP THE GROWNUP FAÇADE.

CUTTING UP A TWISTY ROAD, WHEELIES, ENDOS,
AND BURNOUTS ARE GREAT STRESS RELIEVERS.
I ACT LIKE A HOOLIGAN ON A BIKE.

THERE'S TWO KINDS OF RIDERS,
"THOSE THAT HAVE BEEN DOWN,
THOSE THAT ARE GOING DOWN."

Ed "Giant Squid" Fox
Funeral Director • Riding 24 years
Kawasaki 2001 ZRX, 1999 Suzuki SV 650 (Track),
2001 Kawasaki GSXR 1000 (Street)

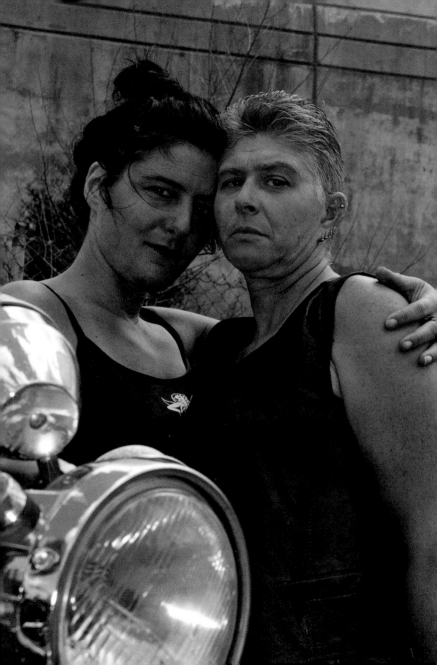

WE FIT. MOTORCYCLES ARE AN EXTENSION OF WHO WE ARE IN EVERYDAY LIFE. THE BIKE AND STILETTO BOOTS MAKE ME FEEL TOUGH, STRONG, TALL. NOT A GIRL, A WOMAN; IT'S EASIER ON SOCIETY'S EYE TO SEE A MALE PRESENCE RIDING WITH A FEMALE, RATHER THAN FEMALE WITH FEMALE; BITCH ON THE BACK, NOT BUTCH. THE SENSUALITY AND SEX OF IT ARE ONE FOR ME—FOR US. RIDING IS PROTECTION, FREEDOM— US AGAINST THEM. —F.S.

WE'RE EDGE PLAYERS, NOT WEEKEND WARRIORS. MY LEATHER IS MY SECOND SKIN, NOT JUST PROTECTION. IT'S WHO WE ARE, COMMITTED TO OUR COMMUNITY AS DYKES AND LEATHERWOMEN, ALWAYS RUNNING THE RISK OF BEING HARASSED, BEATEN, MADE INVISIBLE.

NO HELMET UNLESS I HAVE TO; IT'S ANARCHISTIC, PRIMITIVE. SOME DO IT WITH HOT RODS, SOME ROCK CLIMBING. WE CHOSE MOTORCYCLES. —D.R.

✦

Felice Shays

Sex Educator/Performance Artist/American Sign Language Interpreter · Riding 2 years · Honda 750 Vulcan

Diana "D" Richter · Educator · Riding 20 years

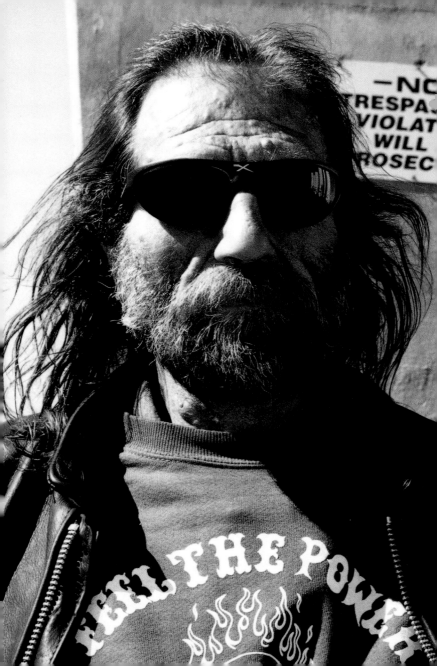

I RIDE BECAUSE IT'S THE ONLY THING
LEFT THE GOVERNMENT CAN'T CONTROL.

AS A BIKER YOU'RE REALLY A
TARGET OUT THERE.
GIVE US A FUCKIN' BREAK —
DON'T AIM AT US!

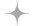

Gary Kralovenec
Construction Worker + Riding 20 years
1989 Harley-Davidson Heritage Road King

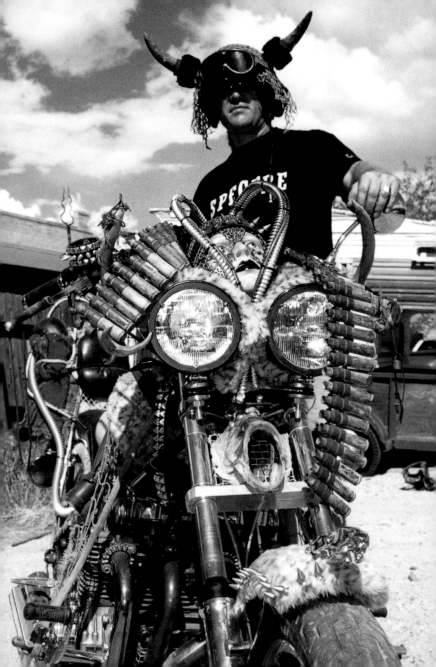

SAY A PRAYER EVERY TIME YOU SADDLE UP,
AND DON'T RIDE LIKE AN IDIOT.
PUT YOUR FEET DOWN WHEN YOU STOP.

I RIDE BECAUSE IT BEATS WALKING.

Neil "Junk Man" Weismiller
Artist/Entrepreneur · Riding 20 years
Hard Tail Kawasaki 1400 cc "Voodoo Bike"

Respect Weather

Patches Ahead

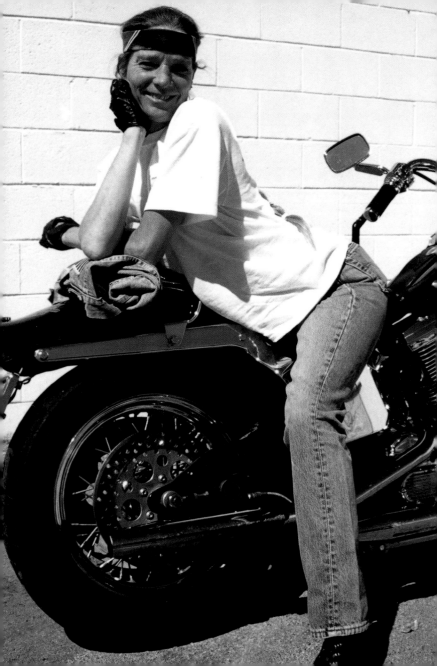

I RIDE BECAUSE I'VE BEEN DREAMING OF THIS ALL
MY LIFE—IT TOOK ME 32 YEARS TO HAVE MY OWN.

ALWAYS STAY IN THE INSIDE LANE WHEN GOING
THROUGH AN INTERSECTION, AND GO THROUGH WITH A
CAR ON YOUR RIGHT.

NEVER BE TOO CONFIDENT—
IT ONLY TAKES ONE IDIOT.

BE HONEST AND ALWAYS HELP
OTHER HARLEY RIDERS.

"Strawberry"
Data-Entry Specialist · Riding 5 years
1997 Harley-Davidson FXST

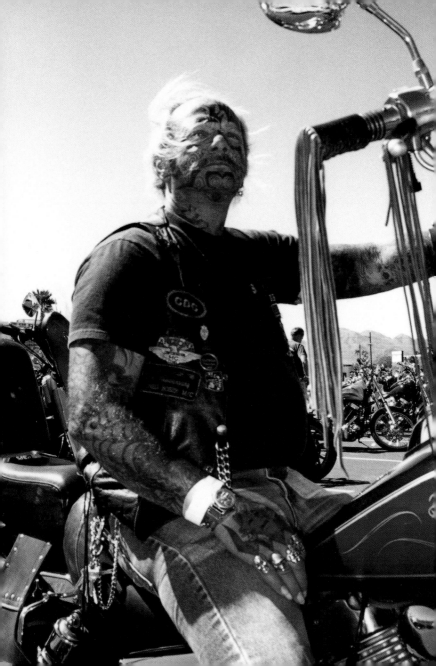

I RIDE WITH "MAORI WARRIOR SPIRALS"
ON CHEEKS AND CHIN.
I RIDE WITH MY BROTHERS
"MUDFLAP," "CRUISER," "NUTS," "NAILS,"
"TALL PAUL" AND "BITCHIN' BOB,"
WHO FOUNDED "STONE SOBER M.C."

OUR MOTTO—"SOBER FOREVER, FOREVER SOBER"

THEY RESPECT ME FOR MY CONSTANT VIGIL TO
"RIDE SOBER."

I HAD MY CRASHES AND SHARE OF ROAD RASHES.
I NEVER RIDE AND DRINK.
I WOULDN'T WANT TO MESS UP MY INK.

Skull

Journeyman Painter
Co-founder of "Stone Sober M.C."
Riding 38 Years • 1998 Kawasaki Vulcan 1500

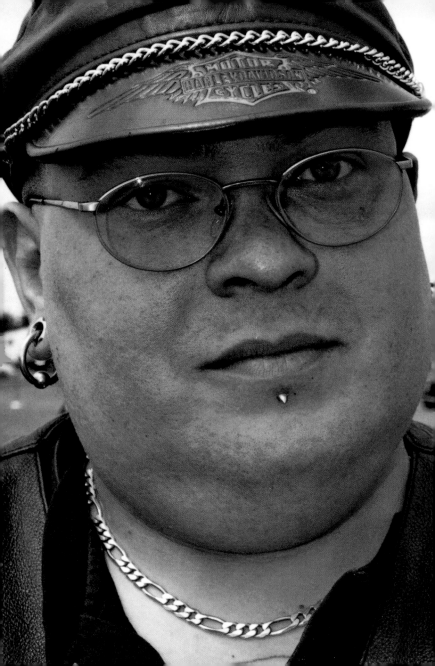

start with steppenwolf bellowing out
"born to be wild."

keep your eyes open.
take a long hard look at the sky.
dress as totally bad-ass as you can,
and whisper,
"wind in my face and my troubles behind, the
more i throttle my bike, the more i unwind."

my helmet sticker, my family motto:
"you say psycho like it's a bad thing."

you have to be a little psycho to ride.
it's a miracle we all don't get run over.

Ruben "Gypsy" Rivera
Truck Driver + Riding 10 years
1990 Harley-Davidson Road Glide

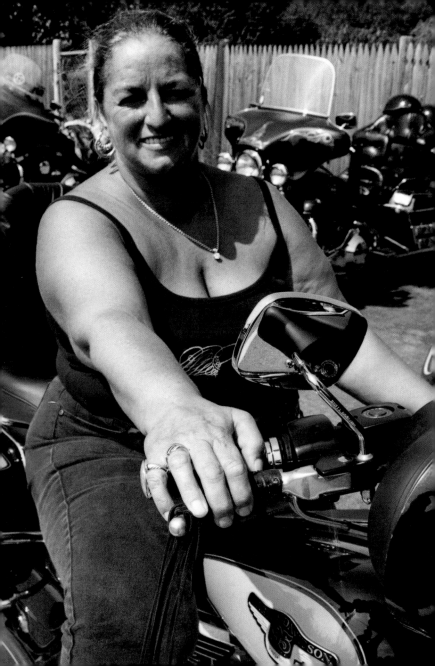

DON'T LOOK DOWN YOUR NOSE AT ME BECAUSE
I WEAR BLACK LEATHER AND LOOK TOUGH.
I'M THE ONE WHO HELD YOUR HAND WHILE YOU
WERE IN PAIN AND SCARED. I'M THE ONE WHO
HELPED YOU WITH YOUR MEDICARE INSURANCE.
I'M THE ONE WHO ASKED IF YOU WERE OK WHEN
YOU HAD TROUBLE BREATHING.

I'M A WIFE OF 33 YEARS.
I'M A MOTHER OF 2 SONS.

I'M AS NORMAL AS THE GIRL NEXT DOOR,
BUT I'M "THAT BIKER CHICK" RIDING THE
LOUD HARLEY, LOVING EVERY MINUTE OF IT.

Nancie Knox
Medical Surgical Assistant + Riding 7 years
1998 Harley-Davidson Anniversary FLHTCI

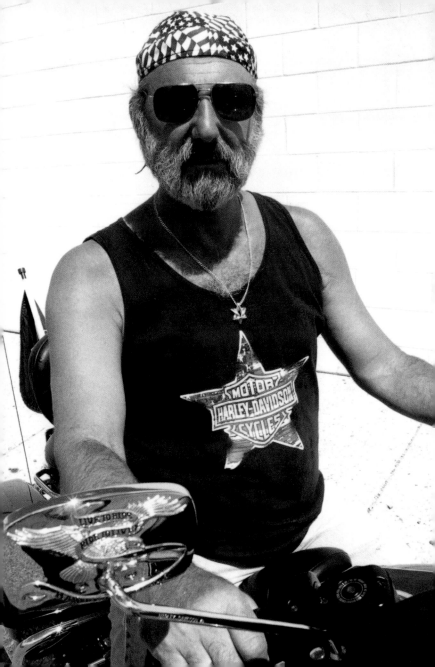

RIDE FOR THE PLEASURE OF THE OPEN ROAD.
BE COURTEOUS TO ALL—BIKE OR CAR.

WATCH OUT FOR YOUNG GIRLS—
THEY HAVE NO RESPECT FOR A BIKE.

NEVER RIDE ANGRY OR PREOCCUPIED.

Martin "Marty" Shapiro
Professional Photographer • Riding 7 years
1998 Harley-Davidson Electra Glide Standard

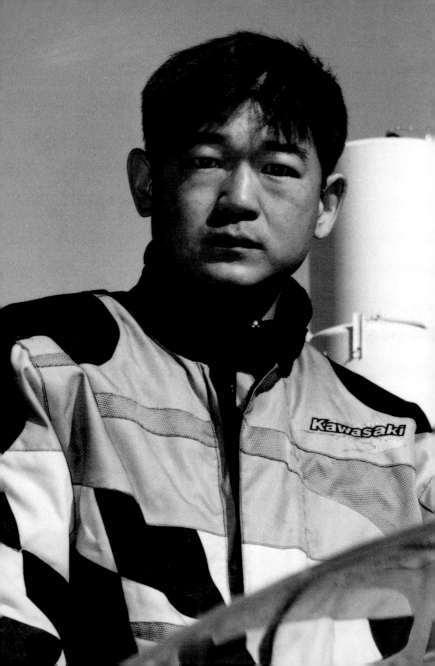

THE MOTORCYCLE IS A VERY
BEAUTIFUL MACHINE.

MY PIPES TALK TO ME WHILE I AM RIDING.

RESPECT YOUR BIKE, DO NOT FEAR IT.

✦

Shyhchin Lee
Systems Administrator · Riding 8 years
Kawasaki ZX9-R

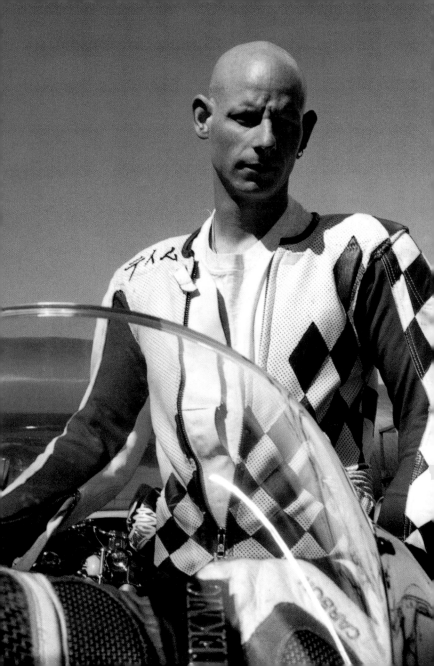

I LOOK DIFFERENT.
PUTTING ON A HELMET ALLOWS ME
TO FEEL THE SAME OR EQUAL AND
THAT ALLOWS ME TO EXPRESS MYSELF
THROUGH THE FREEDOM OF RIDING.

THERE ARE NO BAD EXPERIENCES ON MOTORCYCLES
EXCEPT THE SHALLOW HOSTILITY BETWEEN
AMERICAN AND JAPANESE BIKES.

Tim "Nesster" Rinaldi
Plumber + Riding 25 years
Yamaha Y2F-RI

Never Ride Tired

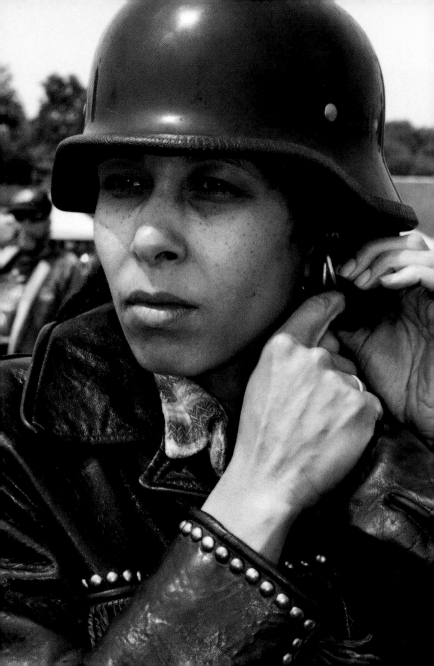

WE NEED TO LAUGH MORE.

BIKERS ARE SOME OF THE FUNNIEST
PEOPLE I HAVE EVER MET.
I LOVE BEING AROUND A LOT OF
DOWN-TO-EARTH PEOPLE.

THE MOST IMPORTANT THING IS CAMARADERIE.

Laura Waters
Mom * Riding 5 years
Harley-Davidson Dyna & Dresser

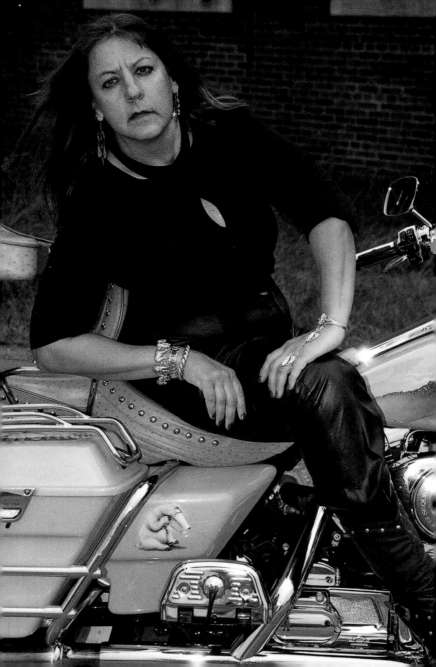

ME! ONE OF THE FIRST FEMALE PROFESSIONAL
FIREFIGHTERS IN THE USA. AFTER 2000 MILES, ONE
MONTH'S RIDING EXPERIENCE, MADE IT TO STURGIS ON A
GORGEOUS HARLEY WIDE GLIDE—A GEOMETRICALLY
CHALLENGING BIKE.

DISCOVERED
CONTROLLING A MACHINE THAT
CAN HURT IS EXHILARATING.

TIRES DON'T PROTECT US FROM LIGHTNING.
WE ARE TARGETS. WE WILL BURN.

"TARGET FIXATION"—"LOOK AT THE TREE,
HIT THE TREE" PHENOMENON.

GUYS KNOW A WOMAN PILOTING HER
OWN MOTORCYCLE IS AN APHRODISIAC.

IT'S YOUR SPORTS SWAYING MOTION
TESTOSTERONE CONNECTION.

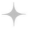

Cindy "Bacon" Bedell
Motorcycle Safety Instructor + Riding 3 years
Harley-Davidson Touring Classic Piggy Pink
2001 Moto Guzzi

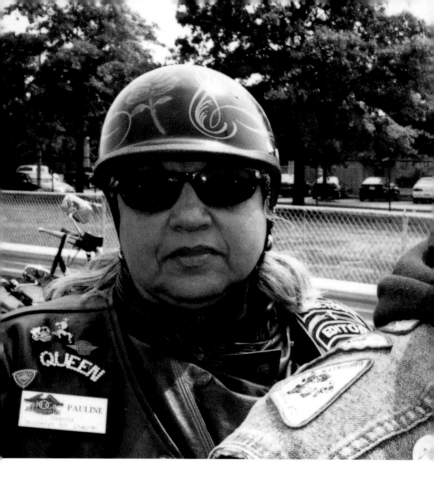

RIDING'S MACHO FOR SOME, SEXUAL FOR OTHERS.
IT'S PRIMAL. IT'S SUNDAY MORNING AND YOU HEAR
THAT PURR—YOU FEEL IT. SENSES ALERT, WIDE OPEN
WHEN YOU'RE ON A BIKE.

Pauline "Queen" Picone
1st Woman President, Brooklyn Harley Club
Riding 13 years + 1993 Harley-Davidson 1200 Sportster

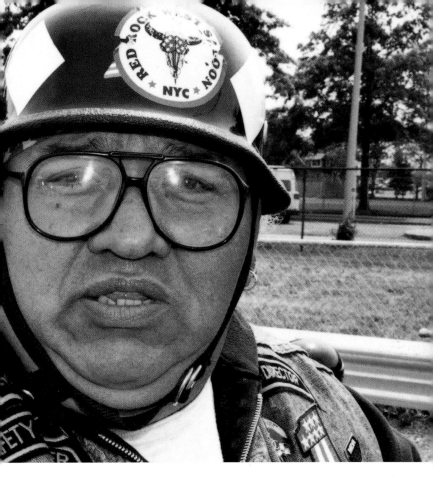

REMEMBER, NO MATTER WHO'S RIGHT, CARS ARE
BIGGER. THE HIDDEN HARLEY GENE IS IN EVERYONE,
BUT NOT EVERYONE IS COMMITTED TO ONE
3-LETTER WORD: FUN.

Sam "Sammy" Picone
Paper and Refuse Recycler ✦ Riding 28 years
2000 Harley-Davidson Road King

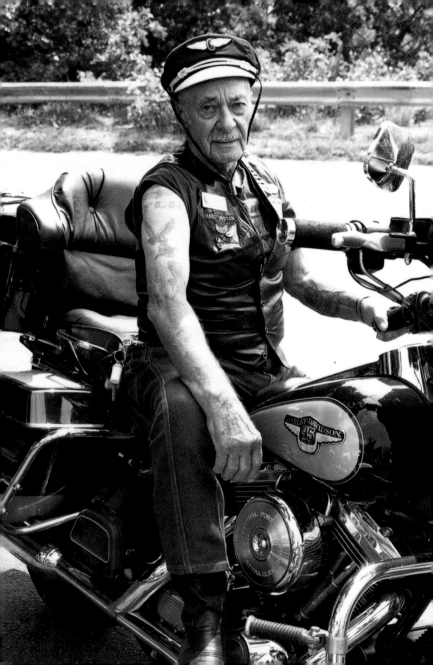

COURTESY AND COMMON SENSE.

Benjamin "Ben" Lewis
Retired · Riding 64 years
Harley-Davidson Ultra

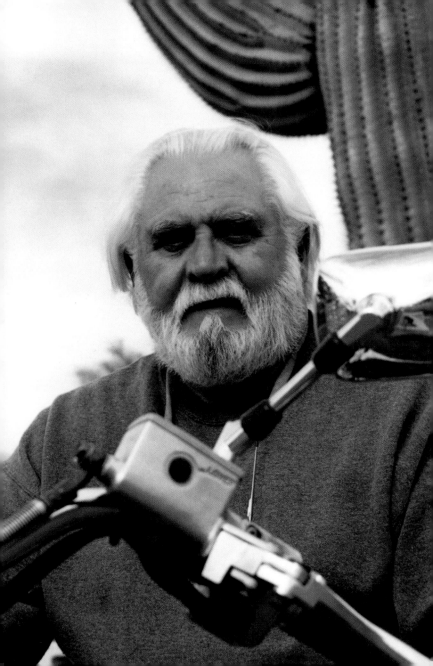

RIDING DEFINES MY MINISTRY AS A TEACHER OF GOD'S WORD. FORTY MILES TO A GALLON ENABLES ME TO VISIT A WIDE SPECTRUM OF PEOPLE, TO WORK A MIRACLE OR TWO ON AN INVISIBLE BUDGET.

LIKE THOSE I SERVE IN LOVE, RIDING BRINGS COMFORT, FREEDOM, POWER AND A RUSH. TO SETTLE INTO A STATE OF "WOW"—THAT ASPECT OF TIME WHICH IS ETERNAL—AND WITHIN IT, TO FIND A CENTER. THEREFORE, RIDING IS LIFE ITSELF.

NEVER RIDE WHEN ILL AT EASE. ALWAYS PREPARE YOURSELF FOR RIDING BY TAKING A MOMENT TO THINK OF GOD—TO RECEIVE HIS LOVE AND SIGHT. BLESS OTHERS ON THE ROAD— HAVE FREQUENT THOUGHTS OF JOY. THIS WILL KEEP YOU OUT OF HARM'S WAY, AND BRING YOU THROUGH MANY TIGHT SITUATIONS.

Jim "Preacher Jim" Martin
Retired • Riding 15 years
Suzuki 1500 Intruder '98

MARC MILLER

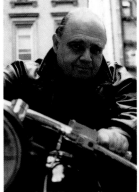

CARLENE HOWARD

StUArT MiLLER

Nicknamed "Zooky from Brooklyn" and known to the suit world as Stuart Miller, the author's diverse talents have gained him recognition as an artist, illustrator, photographer, celebrity interviewer and advertising entrepreneur. Among the luminaries he has photographed are: Grace Jones, Arnold Palmer, the Shah of Iran, Archbishop Makarios of Cyprus, Menachem Begin and Anwar Sadat. Zooky, a biker for over 50 years, currently paints and photographs from his home in Tucson, Arizona, when not experiencing first-hand the thrills of the ride. He created many of these photographs and interviews over a period of several years.

GEOFFREY MOSS

Geoffrey Moss's love of motorcycles began when he was a kid in an Italian neighborhood in White Plains, N.Y. For the last 3 years he's photographed and interviewed biker brothers and sisters. A painter, Moss is also known for MOSSPRINTS, captionless political newspaper drawings, the first of that genre to be syndicated nationally. His graphic metaphors are recognized with Pulitzer nominations, including his *Washington Post* Watergate work. His paintings are exhibited worldwide, and his books include *The Art & Politics of Geoffrey Moss* and several children's books. He holds degrees from the University of Vermont and Yale University. Moss and muse Marion live in New York City.

ACKNOWLEDGMENTS

I would like to thank my son, Marc, who was the motivating force behind this book, and my wife, Alice, who anchored my sanity. I would also like to thank Harvey Bornfield—an inspiring and spirited friend. To Geoffrey Moss, whose relentless passion helped me to realize my dream. I would like to thank Stacey Hood and Gary Chassman for their dedication, noble efforts and presentation. My sincere appreciation to all the bikers who shared their heartfelt wisdom and allowed me to photograph them. By nickname. "Hound Dog," "Snake," "Mongo," "Cisco," "Pee Wee," "Zorro," "Twygsta," "Jester," "Dirty Dog" and "The Queensboro M.C." —S.M.

To my muse and love, Marion Moskowitz, always there, always knowing, always taking the high road! Thanks to hundreds of bikers, passionately sharing "the code," particularly Rob Mackenzie of Western Reserve Harley-Davidson, Tony Gullo, Sal Azzara. Confidants: Leslie and Richard Gottlieb and Seth Moskowitz. To Gary Chassman, pushing us beyond limits, Stu Miller for sharing his dream, my assistant Carlene Howard, creative, invaluable, arriving by divine intervention. Yvette "Half Pint" Pizzella warned: "Try telling how riding feels? Impossible. You must feel it yourself or I'd be stealing a piece of your soul and throwing it away." —G.M.

Enemy Aircraft

SIMON & SCHUSTER PAPERBACKS
Rockefeller Center
1230 Avenue of the Americas
New York, NY 10020

This Simon & Schuster paperback edition 2005

SIMON & SCHUSTER PAPERBACKS and colophon are registered trademarks of Simon & Schuster, Inc.

For information about special discounts for bulk purchases, please contact
Simon & Schuster Special Sales: 1-800-456-6798 or business@simonandschuster.com.

Developed and produced by

Burlington, Vermont
verve@together.net

Designed by Stacey Hood

www.bigeyedea.com

Printed in Hong Kong

7 9 10 8 6

Library of Congress Catalog Card Number: 2002021199
ISBN-13: 978-0-7432-2596-0
ISBN-10: 0-7432-2596-1

THE WIND THE AIR THE MOTION THE MOMENT THE FR

THE BIKE THE RELEASE THE TATTOO THE LEATHER TH

THE COLOR THE MOMENT THE THOUGHT THE TONE

THE SEEING THE FEELING THE DREAMING THE DOING

THE ADRENALINE THE PULSE THE BEAT THE MUSCLE

THE BROTHER THE SISTER THE GIRL THE WAVE THE W

THE DAY THE GIVE THE TAKE THE LIGHT THE NIGHT T

THE BIKE THE FREEDOM THE WIND THE AIR THE MO

THE SPACE THE RHYTHM THE ZEN THE BIKE THE RELEAS

THE GAS THE TREE THE CLOUD THE COLOR THE MOME

THE GOING THE MEETING THE SEEING THE FEEL

THE THRILL THE DANGER THE EMOTION THE ADREN

THE POP THE SPARK THE FRIEND THE LOVE THE BROT

THE SUNSET THE NEW THE PLAY THE FUN THE DAY TH

THE MOON THE SUN THE RIDE THE PRIDE THE BIKE

THE FREEDOM THE RIDE THE FEELING THE SPACE

E RIDE THE FEELING THE SPACE THE RHYTHM THE ZEN

HE SMELL THE ESSENCE THE GAS THE TREE THE CLOUD

ION THE EXHILARATION THE GOING THE MEETING

G THE GIVING THE THRILL THE DANGER THE EMOTION

THE PISTON THE POP THE SPARK THE FRIEND THE LOVE

IFE THE WAY THE SUNSET THE NEW THE PLAY THE FUN

THE FLIGHT THE MOON THE SUN THE RIDE THE PRIDE

E MOMENT THE FREEDOM THE RIDE THE FEELING

TOO THE LEATHER THE SPIRIT THE SMELL THE ESSENCE

OUGHT THE TONE THE PASSION THE EXHILARATION

DREAMING THE DOING THE BEING THE GIVING

PULSE THE BEAT THE MUSCLE THE HEART THE PISTON

STER THE GIRL THE WAVE THE WINK THE LIFE THE WAY

TAKE THE LIGHT THE NIGHT THE RIGHT THE FLIGHT

DOM THE WIND THE AIR THE MOTION THE MOMENT

THM THE ZEN THE BIKE THE RELEASE THE TATTOO